WATERCOLOUR IN BRITAIN

Edited by Martin Myrone

First published 2010 by order of the Tate Trustees
by Tate Publishing, a division of Tate Enterprises Ltd,
Millbank, London SW1P 4RG
www.tate.org.uk/publishing

on the occasion of the exhibition
Watercolour in Britain

Norwich Castle Museum & Art Gallery
(Norfolk Museums & Archaeology Service)
30 January – 18 April 2010

Museums Sheffield: Millennium Galleries
17 June – 5 September 2010

Laing Art Gallery (Tyne & Wear Archives & Museums)
18 September – 5 December 2010

A catalogue record for this book is available from the British Library

ISBN 978 1 85437 887 3

Designed by Rose
Colour reproduction by DL Interactive Ltd, London
Printed and bound in Slovenia by DZS Grafik
Printed on sustainably sourced, certified paper

Cover: Charles Rennie Mackintosh, *Fetges* c.1927 (detail; see p.30)
Title page: J.M.W. Turner, *Geneva* c.1841–2 (detail; see p.37)

Measurements of artworks are given in centimetres, height before width

This exhibition is part of the Great British Art Debate, a partnership project between Tate Britain,
Tyne & Wear Archives & Museums, Norfolk Museums & Archaeology Service and Museums Sheffield,
supported by The National Lottery through the Heritage Lottery Fund.

WATERCOLOUR IN BRITAIN

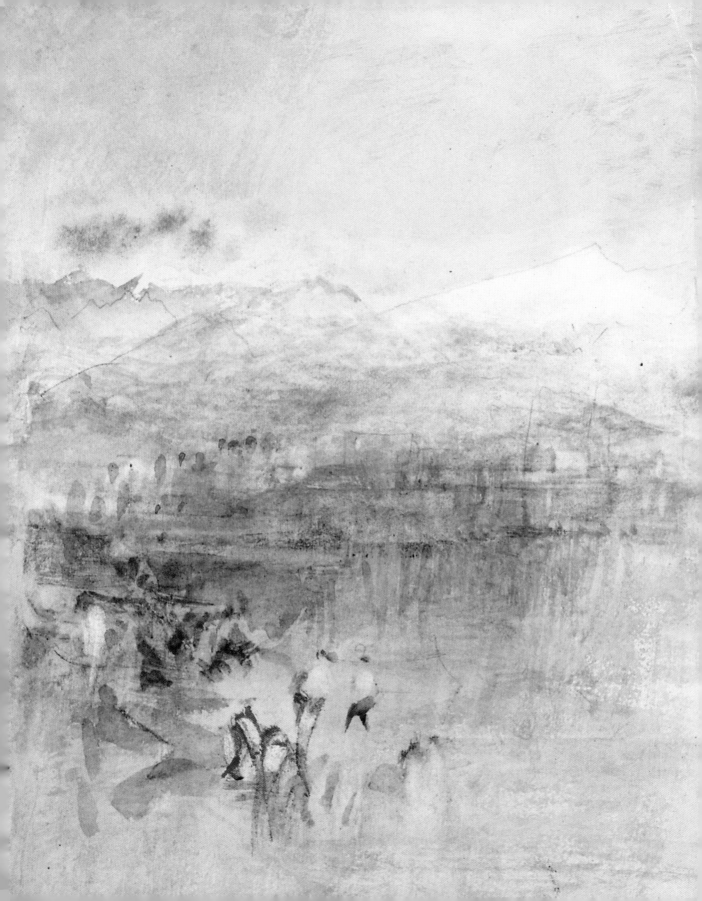

CONTENTS

06
Foreword

09
Watercolour in Britain: A National Art?
Martin Myrone

21
Travelling with Colour
Andrew Moore

33
Tradition and Beyond
Liz Waring

45
Vision and Imagination
Sarah Richardson

58
Selected Bibliography

FOREWORD

Watercolour in Britain has been published to coincide with a touring exhibition
of the same name, organised by Tate as part of the Great British Art Debate, a
four-year partnership project supported by the Heritage Lottery Fund exploring
contemporary ideas about nationhood and identity by engaging people of all
ages and backgrounds with British art. This book, like the exhibition itself, brings
together outstanding British watercolours from all four collections involved in
the Great British Art Debate – Tate, Tyne & Wear Archives & Museums,
Norfolk Museums & Archaeology Service and Museums Sheffield. It is intended
as a celebration of the richness and quality of watercolour painting in Britain,
from the outstanding achievements of artists including J.M.W. Turner, William
Blake and John Sell Cotman, to the splendour of Victorian watercolourists like
John Frederick Lewis and David Roberts, and the highly diverse achievements
of twentieth-century and contemporary artists, including Graham Sutherland,
David Jones and Elizabeth Blackadder.

 In the spirit of the Great British Art Debate as a whole, the exhibition is
intended to be exploratory and questioning, as well as celebratory. The curatorial
teams across the partnership have worked closely together to explore all the
collections as a single resource. Looking with fresh eyes, and with a sense of the
potential diversity of watercolour as a medium rather than a fixed notion of a
correct or pure approach, they have discovered remarkable works, not just by the
well-established canonical figures of watercolour history, but also by talented
amateurs like the Revd James Bulwer and relatively neglected or forgotten figures
like Edna Clarke Hall. Instead of a tidy history of the rise and decline of a 'pure'
watercolour technique, they have discovered an extraordinary technical variety,
with many artists extending or transforming the medium, or combining it with
other media in innovative ways. And they have found a history of watercolour,
that most 'British' of art forms, that is distinctly cosmopolitan and international
in character, whether this involves British artists travelling the world and using
watercolour to capture their experiences, or the diverse cultural backgrounds of
artists working in Britain.

 The five contributors to this book have been drawn from across the
partnership, and each has brought their expertise and insight to the project
as a whole, working together on the selection and organisation of the various

versions of the exhibition seen in the partners' galleries. Martin Myrone, from Tate Britain, took overall editorial responsibility for the present volume as well as playing a leading role in the curation of the project, together with Andrew Moore from Norwich Castle Museum & Art Gallery, Sarah Richardson from the Laing Art Gallery, and Liz Waring from Museums Sheffield. Anna Austen from Tate Britain compiled all the caption texts for this publication, as well as playing a key role in the curatorial development and administration of the project. The selection and formation of the exhibition have been thoroughly collaborative, with crucial contributions being made by Martin Battye, Giorgia Bottinelli, Caroline Fisher, Harriet Godwin, Caroline Krzesinska, Marie-Thérèse Mayne, Julie Milne, Alison Morton, Louise Pullen, Norma Watt, Caroline Whitehead and many others from around the partnership. The project has been managed and steered by Marie Bak Mortensen and Noelle Goldman-Jacob at Tate; Kate Parsons and her team at Tate, notably Nicole Simoes de Silva, oversaw the practical organisation of the tour, working together with registrars and conservators from across the partnership. We are also grateful for the advice and support of, among others, Julia Beaumont-Jones, Rosemary Crill, Mary Ginsberg, Christopher Le Brun, Cedar Lewisohn, Nicola Moorby, Shanti Panchal, Philippa Simpson, Alison Smith, and Ian Warrell. We are also grateful to Judith Severne and Roanne Marner, who have overseen the publication of this book for Tate Publishing.

Caroline Collier
Director, Tate National

Vanessa Trevelyan
Head of Museums, Norfolk Museums & Archaeology Service

Nick Dodd
Chief Executive, Museums Sheffield

Alec Coles
Director, Tyne & Wear Archives & Museums

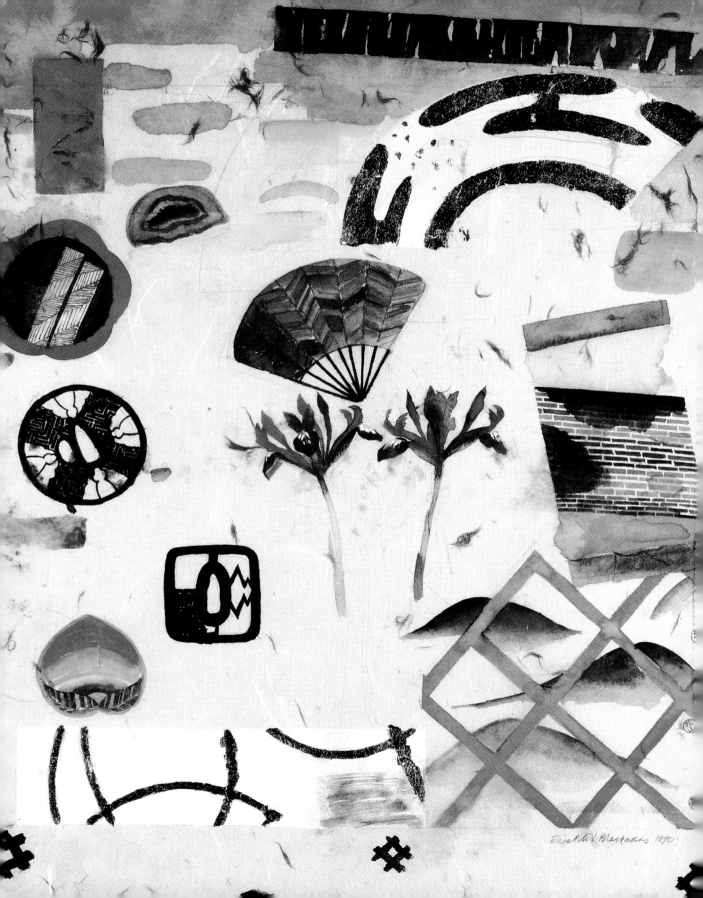

Elizabeth Barakah 1990

Martin Myrone

WATERCOLOUR IN BRITAIN:
A NATIONAL ART?

Watercolour has often been talked about as if there is an essentially 'right' way of using the medium, a pure or correct manner of applying pigment suspended in water (with the addition of some form of gum) to (usually) paper to convey colour, pattern and form. Accordingly, we are often given the idea that there are particularly 'right' subjects for British watercolour painting – primarily the landscape, the sea and old buildings – because these subjects offer such rich opportunities for demonstrating watercolour's capacity for evoking light filtered through foliage, shimmering reflections in water, the brilliance of sunlight or the subtlety of mist shrouding evocative ruins. A whole aesthetic theory, the 'Picturesque', was developed in the later eighteenth century in order to articulate a sense of the pleasure and value to be associated with such informal scenery. According to Picturesque principles, the glimpsed view and the rugged scene that enchant, intrigue, and emotionally involve the viewer have a special value. In the emerging consumer society of modern times – a society based around precisely such transient pleasures – such aesthetic ideals were supremely well suited as a way of understanding art and provided a whole new framework for appreciating watercolour. Watercolour could thus flourish both as a commodity, feeding into a predominantly middle-class market that favoured small-scale works, and as a practice pursued by a growing numbers of amateurs and enthusiasts.

Since the nineteenth century the dominant art-historical narrative has pivoted around the assumption of a 'pure' and correct technique and subject matter for watercolour painting. In its current form, this traces the rise of watercolour from being merely a way of colouring-in prints or drawings in the seventeenth and early eighteenth centuries, to a 'golden age' of truly luminous watercolour painting that runs from the middle of the eighteenth century to the middle of the nineteenth. With artists such as John Robert Cozens (p.24), John Sell Cotman (p.14) and J.M.W. Turner (pp.15, 37) as leading figures, this high point in the history of the medium is said to involve the elevation of everyday subject matter into the realm of the poetic, and a move away from description

and dry precision towards a kind of artless, effortless painterly mark-making which more fully expresses individual genius and originality. This epoch is judged to have lasted until Victorian artists began using the medium for more elaborate figurative compositions (see p.26), painted with lots of opaque bodycolour or gouache. With these technical changes, the purity of watercolour (considered literally visible in the exposed or lightly veiled white surface of paper) is seen as being compromised.

This is an account with powerfully defined chronological contours, technical focus (the use of watercolour in miniature painting, and the endurance of more descriptive or decorative uses of the medium being ignored) and an internationally accepted canon of leading figures. The subsequent story of watercolour is left virtually untold, at least as far as discussions focusing on the 'progressive' forces of modern art are concerned; the use of watercolour in mixed-media paintings by British artists such as Edward Burra (p.52) and Graham Sutherland (p.54) might be considered as almost incidental, both to their work and to the history of twentieth-century art. More recently, watercolour painting has been viewed as largely discredited and irrelevant, too terribly tainted by associations with traditionalism and amateurism.

This story of rise, decline and irrelevance contains within it not only a particular prejudice about the 'real' nature of watercolour as a medium, but also an ideal of British art and the British national character. This sense of a self-evidently correct way of employing the medium has been married to, and helped support, an enduring sense of the value and character of British art in the context of British culture more generally. Both the history of watercolour, and accounts of Britain's culture and history, might be said to be prey to a peculiarly insistent kind of essentialist thinking – the tendency to see things in terms of absolute essences that remain stable over time. The individual freedom and expressive genius of the painters of the 'golden age', the freedom and transparency evident in their watercolours, and the superior freedoms supposedly sustained by Britain's particular political culture, have been cast as mutually supportive. Particularly in the wake of violent revolutions in Europe at the end of the eighteenth century, and a growing movement for political reform in the early nineteenth century, the transparency and directness of watercolour seemed to speak of health and honesty, values cherished as belonging peculiarly to a politically conservative, common-sensical nation like Britain. Watercolour was becoming elevated, as one authority put it in 1891, to a position as 'the truly national art'.

Writing in his *The English Water Colour Painters* (London 1905), the art historian A.J. Finberg – one of the founding fathers of modern watercolour scholarship – could write that 'it has seemed quite natural to speak of water

colour painting as the distinctive national art of England. It is undoubtedly a form of expression suited both to the genius of the English artists and to the taste of the English public'. Putting aside the casual use of 'English' to mean British (nothing unusual in the early twentieth century, and still a commonplace error) Finberg's insistence that the character of both watercolour and the nation 'is essentially an intimate, personal, conversational one' might be questioned, if we took a rather wider view of both. As scholarship has advanced, such views have been considerably refined. The authors of the catalogue accompanying the landmark exhibition *The Great Age of British Watercolours 1750–1880* held at the Royal Academy of Arts, London, and the National Gallery of Art, Washington, in 1993 were careful to draw attention to the interchange between British and continental European artists, yet still insisted on the existence of 'a special relationship between the British character and the medium of watercolour'. In *British Vision* (the ambitious survey of British art that accompanied a major exhibition held in Ghent in 2007), Robert Hoozee noted that watercolour is a 'British speciality', playing a prominent role in expressing what are commonly proposed as the essential national (and essentially paradoxical) British tendencies towards 'observation' and 'imagination'. Even when the notion of a 'national' character of British watercolour has been overtly challenged, as with the significant exhibition *The Art of Watercolour* held at Manchester City Art Gallery and Norwich Castle Museum in 1987, the curator, Julian Spalding, could still insist on a 'pure' ideal of watercolour, characterised by artlessness and authenticity.

There should be no question that landscape painting in watercolour has had an enormously important place in the way the history of British art has been written; that there is a succession of figures whose works have been collected and put on display by art institutions to be enjoyed and studied by generations; and that watercolour as a technique requires certain skills and can produce distinct visual effects. But there exists, nonetheless, a cluster of assumptions about watercolour in Britain that must be interrogated further. Some of these are art-historical, and recent scholarly work in the field (see Bibliography) has led to a much fuller and more critical sense of the place of watercolour in British art and the reasons why its history has been written the way that it has. Historians such as Greg Smith and Kim Sloan have encouraged us to be much more sensitive to the distinctions between 'amateur' and 'professional', and have drawn attention to the tensions and antagonisms that have surrounded the practice of watercolour in the past. More generally, there has been a shift in art-historical thinking which has unsettled the assumption that to any informed viewer the distinction between great artists and the minor figures is self-evident. Historians and critics are now more inclined to think in terms of contradiction, inconsistency, and

incoherence, rather than neat stories and art-historical successions; curators and educators are more open to a variety of responses among gallery visitors; and the audience too may be more aware of the prejudices and assumptions (whether racial, social or gendered) that can underpin such ideas as 'purity' and 'authenticity'. Accordingly, we should be more accepting of the variety of watercolour techniques than past commentators have been, and thus less concerned to insist that 'pure' watercolour, applied fluently and directly to the paper in search of clarity and observational truth, is the absolute model of artistic practice in this medium. Watercolour may be swift and transparent, but it may also be slow and opaque, dark and aggressive, heavy or intense.

But there may be still larger questions we can ask here. What do we really mean when we look at an artwork as an expression or reflection of national character? Are such qualities transferable, carried in a way of looking and a way of painting? Is some innate 'British vision' transmitted too through the views of India or France included here (pp.14, 29, 30), or is it expressed only in images of the native landscape? What of the painters themselves? Do they share a particular way of looking and a way of painting? Does it matter that Dante Gabriel Rossetti (p.17) was the son of an Italian, and grew up in a bilingual household? Does the work of the designer Charles Rennie Mackintosh (p.30) or the poet and painter David Jones (p.55) speak of some distinct local variation of the national character, with the first as a Scot and the second as a London-born child of Welsh and Italian parentage? Do the personal origins of such contemporary artists as Anish Kapoor, born in India (p.42) or Shirazeh Houshiary, who spent her youth in Iran (p.43) matter more or less in an era when 'identity politics' and questions of cultural diversity have become so vital? Do we need, also, to think about gender and class? Was Elizabeth Siddal (p.50), the daughter of an ironmonger, able to imagine herself as an artist in the same way as Rossetti, the son of a teacher and writer?

Whatever we might think about the distinct Britishness of watercolour in Britain, we can also remind ourselves of the global traditions of working in this medium. Looking to the illustrations on the following pages, we can ask if the formal similarities between the eighteenth-century Indian miniature and Rossetti's Pre-Raphaelite watercolour have simply no significance (pp.16, 17), or whether the dense colouring and ornamental design of the British painter's work make it 'impure' as an exercise in watercolour? Similarly, does Elizabeth Blackadder's use of Asian forms and techniques (p.19) make her work 'less British'?

These could all be considered purely as questions for the specialist. But the history of watercolour and the idea of a British national character have been forced together so closely in the past, and are so easily and casually

evoked as a unity now, that there is clearly much more at stake. The images brought together in this book, drawn from four great collections that have themselves partly been shaped by the assumptions and prejudices outlined here, may offer a slightly less tidy sense of watercolour in Britain, one which asks us to look beyond the 'golden age' or a 'tradition' to a more expansive sense of British art *and* British identity.

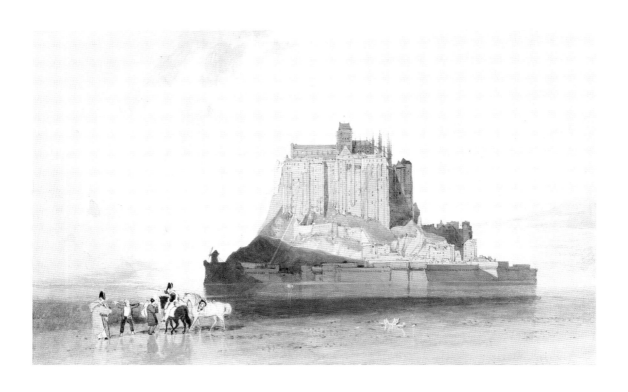

JOHN SELL COTMAN 1782–1842
Mont St Michel 1829
Watercolour on paper 29.1 × 47.2 cm
Laing Art Gallery, Newcastle upon Tyne (Tyne & Wear Archives & Museums)

Prompted by his lifelong patron, Dawson Turner, Cotman toured Normandy in northern France
a number of times, producing some of his most famous architectural watercolours. This image of
Mont St Michel would have been painted on one of these trips. Cotman's Normandy watercolours
have been viewed as exemplary works of watercolour's 'golden age'. He has used thin washes of
watercolour to allow a translucency to his sky, against which the island's buildings could stand out.
The lively, colourful group in the foreground add interest and movement to the scene.

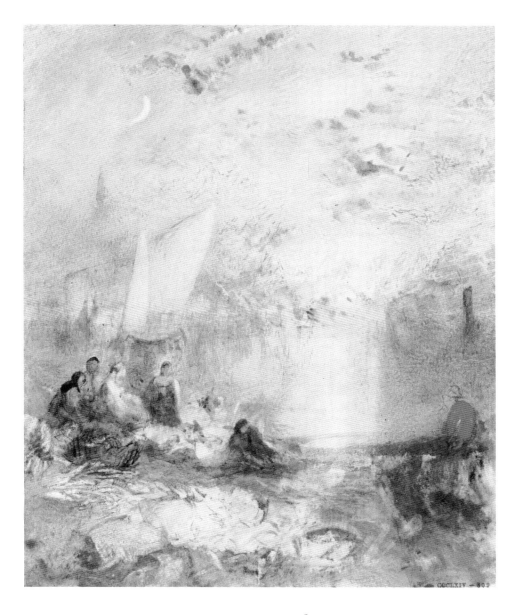

J.M.W. TURNER 1775–1851
Sunset: A Fish Market on the Beach c.1835
Watercolour, bodycolour and pen and watercolour on paper 25.4 × 20.8 cm
Tate. Accepted by the nation as part of the Turner Bequest 1856

Turner painted equally in oil paint and watercolour, and the interplay between these mediums
shaped his approach to landscape. His highly inventive, experimental approach to watercolour has
often been considered as the defining way to use the medium. In this intensely coloured painting,
Turner has set out to transform a humble scene of a fish market into a poetic exploration of colour
and light. Rather than trying accurately to depict the details of this scene, Turner focuses on
the romantic effect of the setting sun, which casts a warm glow over the whole composition.

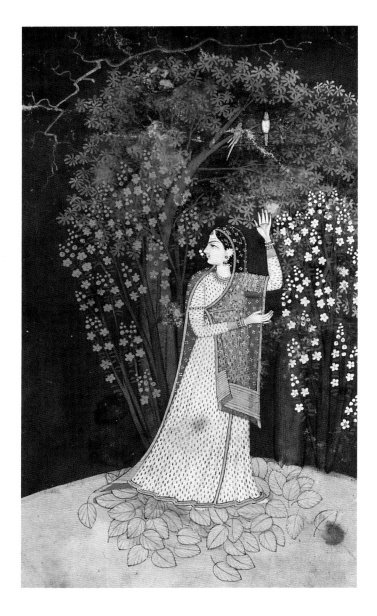

ANONYMOUS INDIAN ARTIST
Lady Wandering in the Forest c.1800
Bodycolour on paper 22.5 × 13.5 cm
Museums Sheffield

This is a Pahari ('hill') painting, named after the mountainous areas where the style
originated. The lady is a 'nayika', one of a cast of lovers shown in different situations. It was
produced as an illustration for a manuscript volume, and is painted in bodycolour (opaque
watercolour). Although distinctly Indian, the strong colours and decorative qualities connect
intriguingly with the Pre-Raphaelite painting by Dante Gabriel Rossetti (p.17).

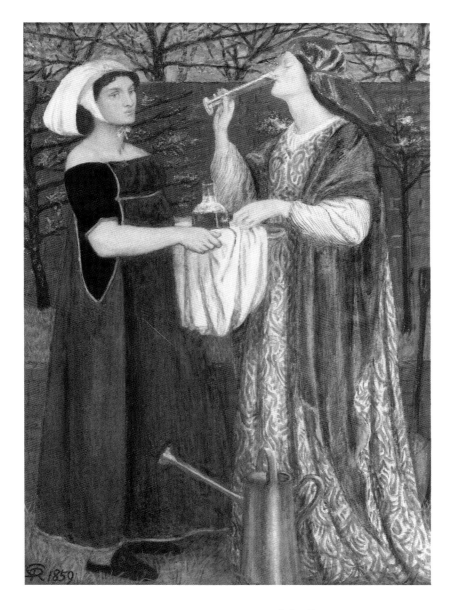

The intense, jewel-like colours of this watercolour, and the emphasis on decorative patterns, are intended to evoke medieval art. Rossetti was a member of the Pre-Raphaelite Brotherhood, which in the 1850s tried to reform British art. This involved rejecting the more expressive and freely painted styles of watercolour that had previously been seen as defining a national British tradition in the medium.

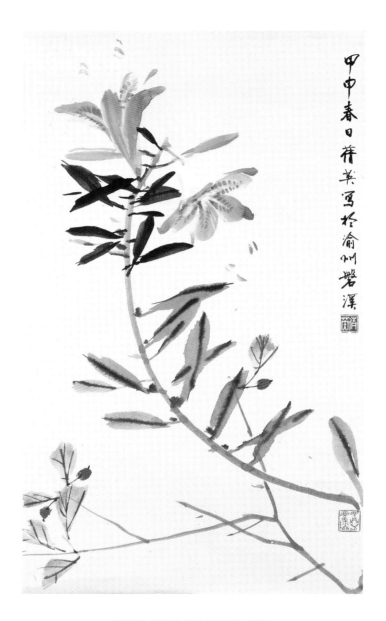

CHIEN-YING CHANG 1913–2004
Spray of Lilies 1944?
Watercolour on paper 54.5 × 32.1 cm
Museums Sheffield

Although we are used to looking at watercolours in frames, hung on the wall, the medium has been
used in many different ways at different times and in different cultures. This flower painting is Chinese,
and takes the form of a scroll that needs to be unrolled. The inscription says 'Painted in the spring of the
jiajia year, by Chien-Ying, by a river near Chongqing'. Chien-Ying Chang studied art in China before moving
to England in 1946 and attended the Slade School from 1947 to 1950. The jiajia year is either 1884, 1944
or 2004, so this work was almost certainly created in 1944 just before Chien-Ying came to England.

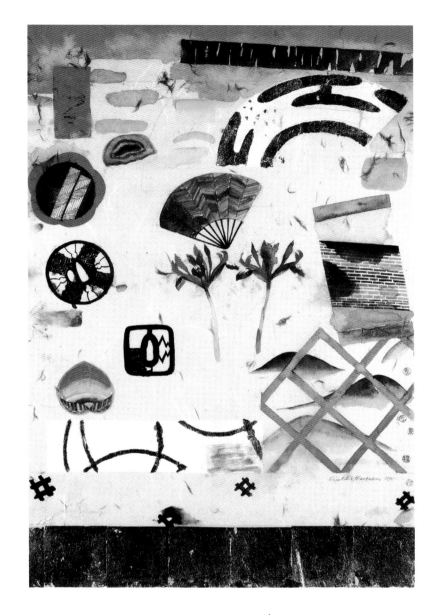

ELIZABETH BLACKADDER born 1931
Still Life with Japanese Swordguards and Fans 1990
Gold leaf and watercolour on paper 76 × 50.5 cm
Laing Art Gallery, Newcastle upon Tyne (Tyne & Wear Archives & Museums)

Elizabeth Blackadder's watercolours often take the themes of traditional still-life painting and transform them into decorative and partly abstract compositions. Her interest in the particular textures of papers and painted marks relates to the watercolour traditions of Asia. Blackadder travelled in Japan in 1985 and 1986, and there is a strong Japanese influence in this work, evident in the stylised swordcases and fans, and the simple rounded mountains in blue and green.

Andrew Moore

TRAVELLING WITH COLOUR

The development of watercolour in Britain is traditionally seen as a journey from the combined use of direct observation and tinted drawing to a more lyrical and free use of the medium, especially when defining landscape. As the following selection of works demonstrates, the desire to record topographical views extends far beyond the origins of the use of the medium to map the geography of the landscape. We see artists responding to the immediacy of new experiences, at home and abroad, across time.

A key aspect of the medium of watercolour is its portability, making it an effective aid for an artist to select and record the seen, while also discovering the overlooked. It provides amateur and professional artists alike with the opportunity to set down on paper their visceral response to the experience of travel in Britain and abroad. This portability is also a key to appreciating the essentially democratic nature of the medium. A number of the artists whose sketches and drawings in watercolour now reside in national collections around the country may be regarded as amateurs – simply because they might have had other positions in society, not strictly earning their living as painters. For example, the Revd James Bulwer (p.38) and the Revd Edward Thomas Daniell (p.28), inspired by friendship with artist circles and their antiquarian and travel projects, achieved recognition for their draughtsmanship that went far beyond mere imitative and contribute to the idea of an inclusive national school of watercolour painting.

From the period 1750–1850 onwards the amateur watercolourists of Britain have also been testament to the achievements of the many artists employed as teachers and drawing masters, whose lessons their pupils duly applied, often with signal success. The national school embraces not only those artists who started as pupils and ended as masters of the medium in their own right, but also artists who disseminated their teacher's style if not their complete mastery. John Robert Cozens outstripped the talents of his father

EDWARD THOMAS DANIELL, *Interior of Convent, Mount Sinai* 1841 (detail, see p.28)

Alexander, adding a poetic quality to his compositions (p.24), which were nevertheless based upon the real landscape, rather than the imaginative blotted shapes that his father espoused. John Sell Cotman also outstripped his contemporaries (p.14), while his career as a teacher has imprinted a 'Cotmanesque' style on the national school.

The democratic nature of the medium had one other strong point that was to enhance its national reputation. Amateur enthusiasts often became important patrons, driven by their desire both to support artists and to develop their own experience of the fluid application of paint and master the depiction of light in its many forms. Dr Monro was one such patron, whose personal enthusiasms nurtured the talents of Turner, Cotman and Thomas Girtin. George Beaumont, whose urge to bring the poets Wordsworth and Coleridge together was matched by his own hunger to paint the landscape of the Lake District by brush if not in words, became an amateur watercolourist on his travels. Wordsworth complimented the patron for his talent with pencil and colour.

The wish to travel is often one of the key motivators for the watercolourist, whether to a favourite spot nearby, to explore the home territory, or to visit further afield, exploring the exotic or unusual. Travels abroad for the British painter since the eighteenth century have often embraced the most well-worn tourist routes across Europe in particular, dictated by fashion and reputation. Rome was at the heart of the European tour during this period, and John Frederick Lewis was painting in a long tradition of artist travellers when he recorded the Easter Day papal blessing during his two year visit to Rome, capturing the moment as well as place with initial sketches prior to producing a finished exhibition watercolour (p.26). Classical tradition was a significant influence upon the British painters in search of sites and John Robert Cozens in depicting Castel Gandolfo overlooking Lake Albano just to the south of Rome was responding as much to the ancient association of the place as a home of the Emperor Domitian and the natural beauty of the place as to the fact that it was then a papal palace (p.24).

Other journeys are more exploratory, seeking out places touched by the tradition of pilgrimage, such as Daniell's depiction of the Convent of St Catherine at Mount Sinai (p.28) or Edward Lear's tours of the Middle East, which he recorded in watercolours that acted as a diary of travel, inscribed with time of day as well as date, as in his panoramic view of the river Nile at Assouan. Another traveller in the Middle East was David Roberts, seeking to record the great sites of Egypt, yet his travels through bandit country in Spain (p.25) were equally adventurous: in both cases, Roberts's principal quest was architecture. One of the most-travelled artists was Turner (p.37) who embarked, sketchbook in hand, upon some forty journeys throughout his

career, at home and abroad, exemplifying in the process the dual search for new vistas and corresponding atmospheric effects, fed by the demands of exhibition, patron or publication.

We may reasonably question whether there is anything intrinsically 'British' about the use of watercolour, but British artists have consistently travelled to other climes and taken their pencils and colours with them. Today the medium remains an emphatically democratic one, used by amateur and professional artists to observe and explore in much the same way as throughout its history. Even conceptual artists or sculptors such as Anish Kapoor (p.42) may explore the internal, existential landscapes of the body and mind, pushing the medium across a sheet of paper in search of colour, light and form, chasing shadow and chiaroscuro, in a manner made possible by the explicit fluidity of the medium.

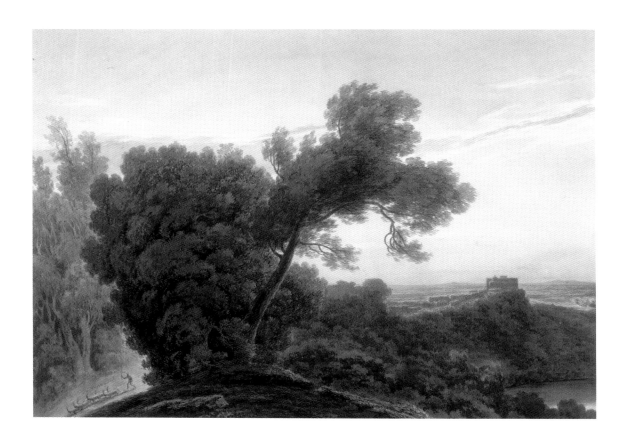

JOHN ROBERT COZENS 1752–1797
Lake Albano and Castel Gandolfo c.1783–8
Watercolour on paper 48.9 × 67.9 cm
Tate. Presented by A.E. Anderson in memory of his brother Frank through The Art Fund 1928

John Constable (1776–1837) considered Cozens to be 'the greatest genius that ever touched landscape'. With Thomas Girtin, Turner and Cotman, he is considered one of the heroic founders of the 'golden age' of British watercolour. This watercolour of Lake Albano in the Alban hills near Rome is typical of the idealised romantic views for which Cozens was most celebrated. This painting was produced for the wealthy collector William Beckford (1760–1844) when Cozens toured Italy for a second time in the 1780s, producing over a hundred Italian views for his patron.

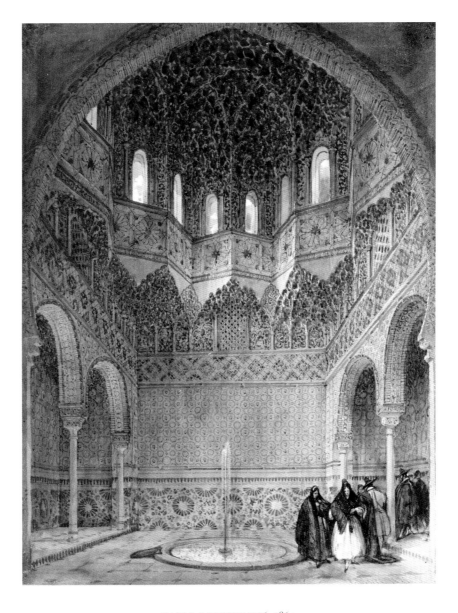

DAVID ROBERTS 1796–1864
In the Alhambra Palace, Granada 1834
Bodycolour, pencil and watercolour on paper 32.7 × 23.2 cm
Laing Art Gallery, Newcastle upon Tyne (Tyne & Wear Archives & Museums)

By this time some adventurous artists were going far beyond the traditional route of the Grand
Tour through France and Italy, to see more distant and unfamiliar landscapes. This watercolour
was painted from sketches made by Roberts during his 1832–3 tour of Spain. The richly
decorated Alhambra Palace at Granada was built from the mid-thirteenth century onwards,
during Islamic Arab rule in Spain. Roberts produced a large quantity of watercolours on his
tour of Spain that conveyed a new interest in what were viewed as thrillingly 'exotic' themes.

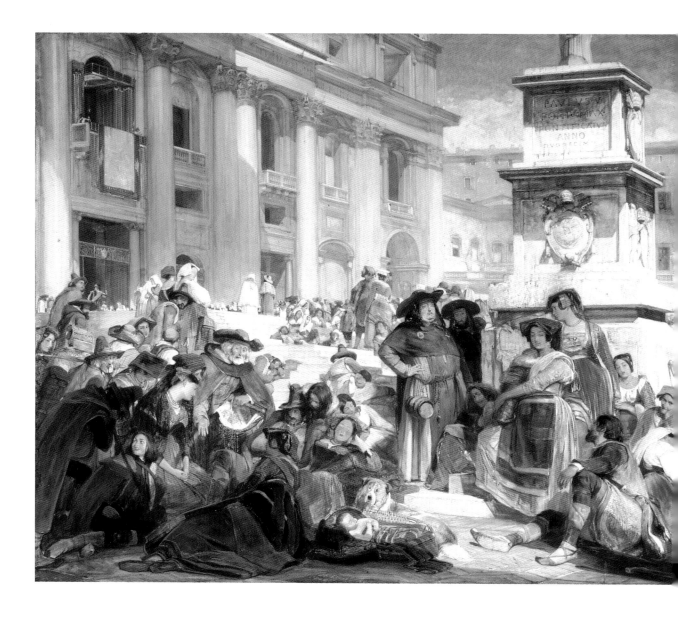

JOHN FREDERICK LEWIS 1805–1876
Easter Day at Rome 1840
Watercolour on paper 77 × 133.5 cm
Laing Art Gallery, Newcastle upon Tyne (Tyne & Wear Archives & Museums)

This large and richly coloured watercolour depicts the Easter Day blessing by the Pope in Rome. Crowds of people have travelled from surrounding villages and towns to receive the blessing and are shown waiting in front of St Peter's Basilica, brightly dressed as it is a day of celebration and festivity in the Christian calendar. Lewis would have witnessed this event when he visited Rome in 1839–40 where he produced two watercolours of this scene. He exhibited one of them at the Old Watercolour Society in 1841: the bustling activity, large size and colourful character of this painting were intended to grab viewers' attention in the context of such public exhibitions.

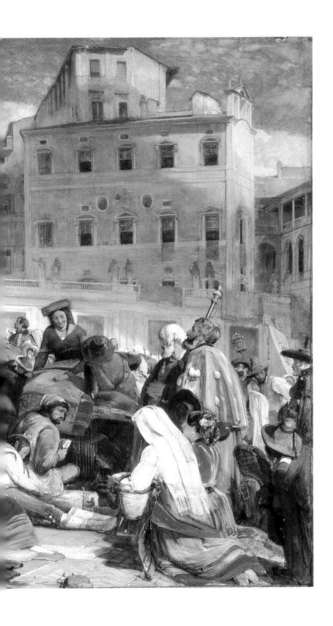

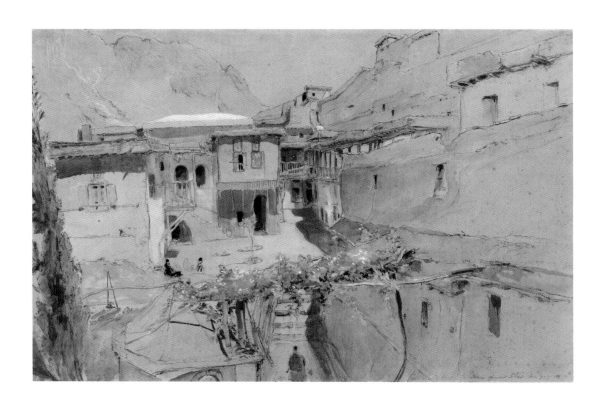

EDWARD THOMAS DANIELL 1804–1842
Interior of Convent, Mount Sinai 1841
Watercolour, ink and bodycolour on paper 33.1 × 49.2 cm
Norwich Castle Museum & Art Gallery

The Revd Edward Thomas Daniell was an amateur artist who was a close friend of David Roberts
(p.25). Perhaps prompted by Roberts's painting tours of the Middle East, Daniell left England
in 1840 for a two-year tour of the eastern Mediterranean, reaching Sinai in 1841. It was here that he
painted this watercolour of a convent on Mount Sinai in his characteristic loose pen and wash style.
The convent was an important stopping-off point for travellers; the church contained the bones of
St Catherine and it is also the site where God is supposed to have appeared to Moses in the burning bush.

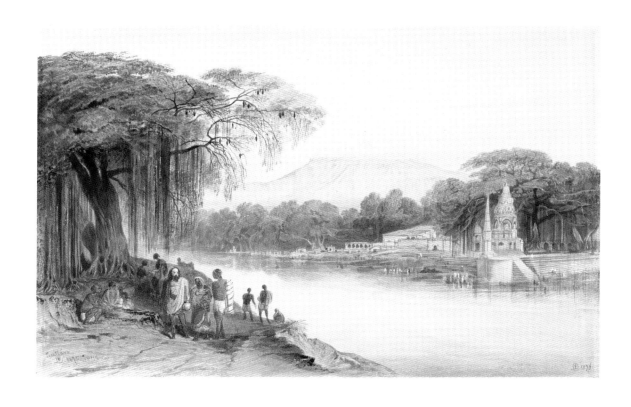

EDWARD LEAR 1812–1888
Satara 1875
Watercolour on paper 26.5 × 40.6 cm
Museums Sheffield

Edward Lear spent much of his life travelling and painting, although today he is best remembered
for his nonsense poems. He was a prolific artist, often producing five or six on-the-spot sketches
per day, adding colour washes to them at a later date. This watercolour was produced when Lear
toured India (then under British colonial rule) towards the end of his life. He wrote in his journal:
'The way thither left me nearly mad for sheer beauty and wonder of foliage! O new palms!
O flowers! O creatures! O beasts! Anything more overpoweringly amazing cannot be conceived.
Colours and costumes and myriadism of impossible picturesqueness'.

CHARLES RENNIE MACKINTOSH 1868–1928
Fetges c.1927
Watercolour on paper 47.4 × 48 cm
Tate. Presented by Walter W. Blackie 1929

The Glaswegian architect and designer Charles Rennie Mackintosh travelled in France towards the end of his life and produced many watercolours depicting villages and landscapes. In this painting Mackintosh explores the use of line and geometric form learnt from years producing architectural drawings, but transfers these skills to the medium of watercolour and the genre of landscape painting. This view of a village nestled high in the Pyrenees focuses on the patchwork pattern of surrounding fields seen from above for abstract effect.

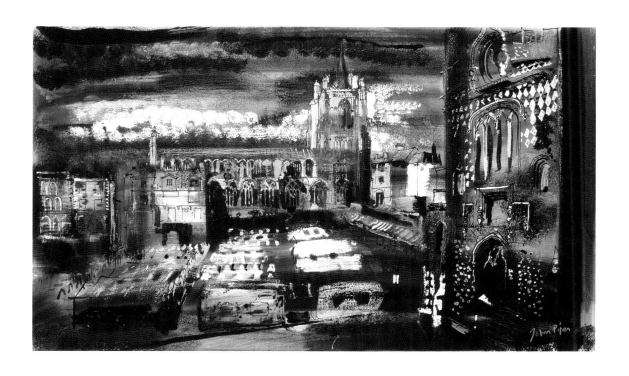

JOHN PIPER 1903–1992
Norwich Market Place c.1950
Pen and ink, watercolour and chalk on paper 41.4 × 69.5 cm
Norwich Castle Museum & Art Gallery

John Piper's design sits within a longstanding tradition of topographical watercolours, which
were intended to convey a specific sense of place based on the artist's direct observations. The
technique, incorporating chalk and pen and ink as well as watercolour, is, however, distinctly
modern, as is the complex approach to the representation of space. The design was a sketch for
an oil painting, now in the collection of Leicestershire Education Committee, and commissioned
by the manufacturing firm of Boulton & Paul, Norwich for reproduction in a calendar.

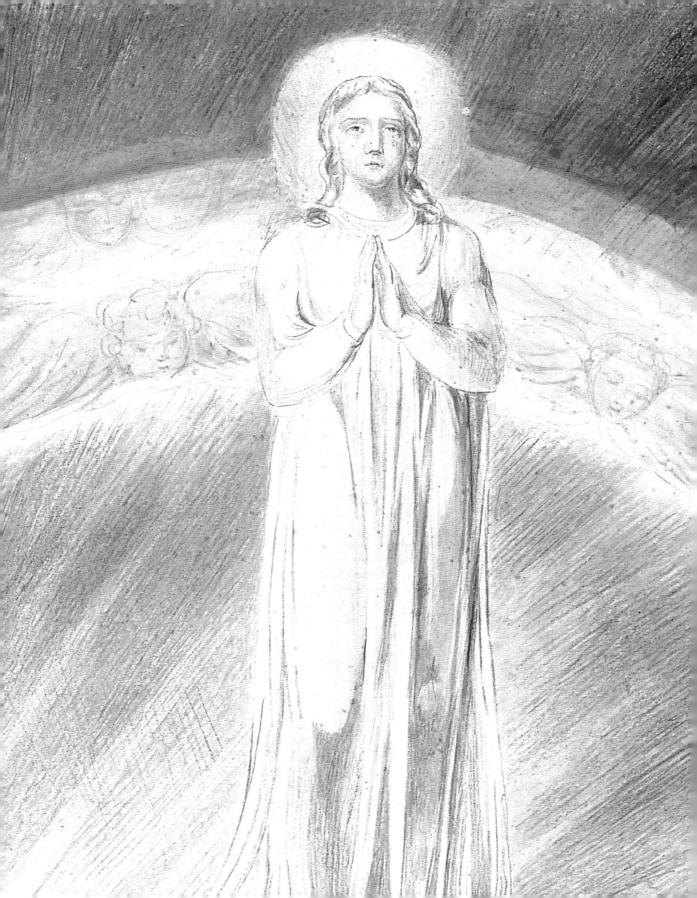

Liz Waring

TRADITION AND BEYOND

Watercolour is a spectacularly versatile medium that has captured the imagination of artists for centuries. Appealing to both the professional and amateur alike, its very simplicity is its strength, offering a huge variety of effects and endless possibilities. It seems that there is no longer a 'tradition' of watercolour, but a rich medley of techniques that are still continuing to evolve to this day.

Was there ever a single tradition of watercolour, or has it always been in transition? The historical emergence of the medium has been associated with the growth of topographical views and tinted prints in the seventeenth century. This was watercolour at its 'purest', where simple lines describe the scene and controlled washes of dilute colour added light and shade. Indeed some artists continued this pure use of watercolour well beyond the days in which it was fashionable.

In that respect, we could say that Edward Lear was a traditional watercolourist, as he was particularly well known for using this simple wash technique. In his painting of *Satara* 1875 (p.29) for example, the pencil lines in the distant mountain can be clearly seen through a delicate transparent wash. Although Lear was self taught, his grasp of the medium was masterful. His works retain the strong lines and composition of topographical painting, but move beyond it through his free handling of the paint. He frequently made extensive pencil sketches on the spot with detailed notes about colour and composition, which he later worked up with colour and 'penned out' with ink.

William Blake was another acknowledged master of watercolour. As a trained engraver, the use of line is again paramount to his work. His images can be seen as an illustration of his thoughts, yet they evoke a clarity and translucence that perhaps only watercolour could convey. In *The Death of the Virgin* 1803 (p.36), his decisive but delicate use of line is complemented by radiant colour, adding an ethereal brilliance to this religious work. He has left areas completely untouched so that the pure white paper and subtle pencil lines shine through making the figures almost glow with light. Blake has chosen the

WILLIAM BLAKE, *The Death of the Virgin* 1803 (detail, see p.36)

perfect medium for his lively imagination, though his choice of technique was secondary to the vision he wished to convey through his illustrations. Subsequently, with their use of underdrawing and delicate colour and washes, even those artists that seem closest to the origins of watercolour can be seen to incorporate their very own style and techniques.

J.M.W. Turner's use of watercolour has been considered to be the epitome of style and technique, and one would always associate his name with the watercolour tradition. Yet his use of the medium was so experimental and so accomplished it transcends the 'traditional' label. Initially, Turner did follow established topographical approaches, but he then began to experiment, no longer seeing watercolour as merely a kind of coloured drawing. Instead, he wanted to capture the atmosphere of a place; to recreate the emotion he felt when he looked at a view. In *Geneva* c.1841–2 (p.37), he has soaked his paper in water and blended the colours on the surface creating an ephemeral impression of the scene. His figures are only suggested with quick strokes of the brush and the overall feeling is of colour and light.

In *Sunset: A Fish Market on the Beach* c.1835 (p.15) this wet paper technique is again apparent, although the image is more highly worked up than *Geneva*. Turner thickened his watercolour paint with gum and used the end of his brush to scratch into the paint to delineate the fish. He created the bright golden sand in the foreground by scrubbing his bristles into the thickened paint. A flick of the wrist with a dry brush has drawn up a crescent of colour from the surface of the paper to leave a white moon peering through the sundrenched sky. He may have even used a gum resist to reveal the sails of the boats, masking the shape with gum before covering it with a coloured wash, then rinsing it away to reveal the pale paper beneath.

Turner's experimental use of the medium was an inspiration to many artists. Not least of these was John Ruskin, who advocated watercolour as the most successful medium for capturing the subtleties of light, details of landscape and for accurate colour blending in paint. Despite frequently putting brush to paper, Ruskin never actually considered himself an artist, but merely used this medium to record and detail facts about his subject matter. He has captured these facts with perfect clarity in *Study of Leaves on a Rocky Riverbank* 1875–9 (p.39). Using gouache or bodycolour, a less translucent watercolour where the pigment is mixed with white paint, he has highlighted the intricate detail of every frond. In his writings he advised: 'Use Chinese white, well ground, to mix with your colours in order to pale them, instead of quantities of water. You will thus be able to shape your masses more quickly, and play your colours about with more ease.' Another of Turner's techniques was experimenting with coloured papers and Ruskin has used the cold

blue of the paper to add a certain stone-like quality to the rocks and achieves through it a strong contrast of light and shade.

Each artist's motivation for the use of this traditional medium was as varied as its technical effects. Lear, who travelled extensively, valued its portability and delicate colours (p.29); Blake its translucency and clarity akin to the frescos he so admired. For Turner it was his cross-experimentation with both watercolour and oil that led to his mastery of both, while for Ruskin it was a means to an end in recording the world around him. In contrast, Edward Burra preferred its ease of use above anything else. Always in poor health and invariably fatigued, he found that watercolour needed little physical effort in its application.

Burra's vibrant works may seem far removed from tradition, yet some of his techniques do echo the past. His watercolours began with a pencil drawing and have a loosely washed ground, but in his composition the break with tradition can clearly be seen. For *Soldiers at Rye* 1941 (p.52) he started his drawing on a single sheet and then added further sheets as the composition progressed and grew. This leads to a dramatic change in scale of the piece and it has become an unusually large work for the watercolour medium. He has also used a range of techniques to produce the desired effect, such as incising into the paint to create the delicate netting on the left. In other areas he has used layers of gouache to provide highlights that contrast with the dark areas of ink, while some of the soldiers' faces have been blurred with water to add a surreal uncertainty to the scene.

Anish Kapoor takes watercolour one stage further. His work highlights the twentieth-century approach of using whichever technique best conveys the desired effect. His use of watercolour is more about the process than what he is trying to represent; the resulting image is not planned but evolves through this use of the medium, an unconscious act. He states: 'what I am trying to do is to make a picture of the interior, the interior of me.' To Kapoor the dilute pigment, predominantly made up of water, is used to suggest this 'act of creation'. Colour is also vital to his work as he believes that the knowledge of colour symbolism is innate in us all. In *Untitled* 1987 (p.42) he has covered the paper with a dark wash of brown representing the earth; in fact he has occasionally used earth itself to supplement the pigment. He has then allowed the yellow pigment to bleed into the brown, creating its own form without any further intervention. The material character of watercolour is fundamental to his work.

In considering these artists and their diverse use of the medium, can the watercolour tradition be seen as more of a ideal, or even an illusion, than a style? Perhaps it does not relate to the way the paint is actually applied but more to its ability to inspire artists and fulfil their desires. Whatever the answer, it is the versatility of the medium that is its strength: its ability to be used by anyone.

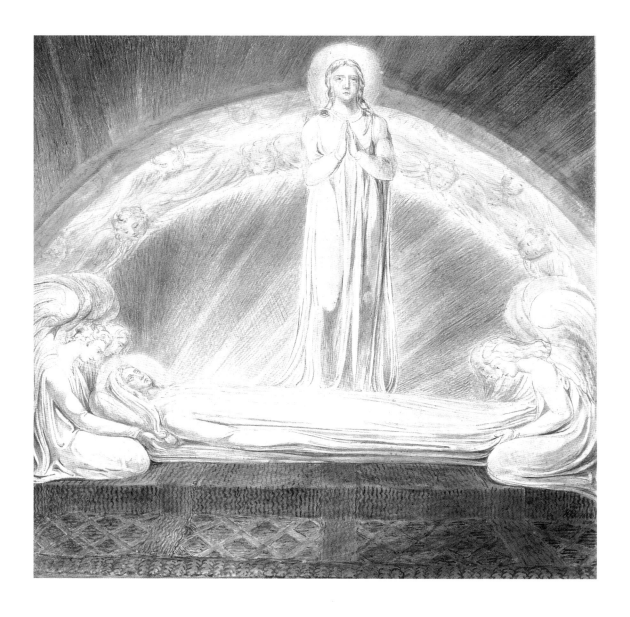

WILLIAM BLAKE 1757–1827
The Death of the Virgin 1803
Watercolour on paper 37.8 × 37.1 cm
Tate. Presented by the executors of W. Graham Robertson through The Art Fund 1949

William Blake was a visionary artist who was little understood in his own time but later became a
source of inspiration to many artists. His watercolours often illustrated biblical and literary themes.
Although most watercolour artists of the time were exploring more fluid and expressive ways of painting,
Blake used the medium to emulate the painstaking style and clarity of medieval fresco wall paintings. This
watercolour was one of a series painted for his patron, Thomas Butts. In a strictly symmetrical composition,
the body of the Virgin Mary is supported at both ends by angels as though she were a medieval tomb effigy.

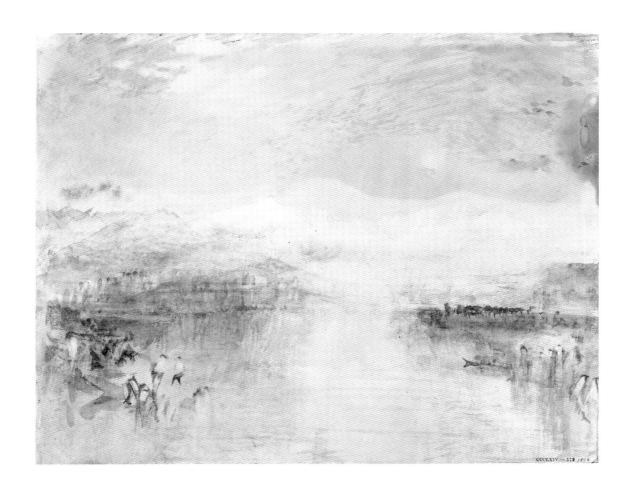

J.M.W. TURNER 1775–1851
Geneva c.1841–2
Bodycolour, pencil and watercolour on paper 23 × 29.4 cm
Tate. Accepted by the nation as part of the Turner Bequest 1856

Turner painted Lake Geneva repeatedly throughout his career, exploring the different effects
of reflected light in the sheer surface of the water. This design originated in sketching tours of Switzerland he
undertook in 1841 and 1842. The watercolours that resulted from this trip are among the most atmospheric
that he created. By this point in his career, he was often subject to criticism from writers and viewers who
thought his art was becoming too wild and experimental. Today, Turner's later paintings are widely considered
to be his greatest achievement, and are often seen as laying the foundations of a modern approach to painting.

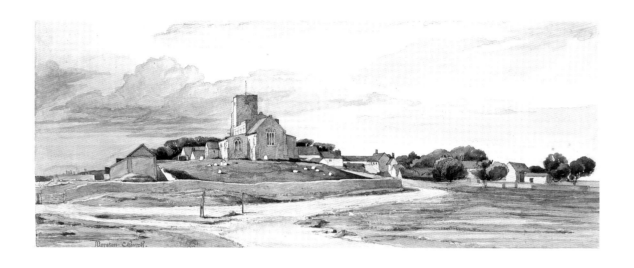

JAMES BULWER 1794–1879
Morston Church c.1855
Watercolour on paper 16.8 × 39 cm
Norwich Castle Museum & Art Gallery

The Revd James Bulwer was an accomplished amateur artist and a keen antiquarian. He was a close friend and pupil of the Norfolk-based artist John Sell Cotman (p.14), and this watercolour clearly recalls that artist's work, with large areas of strong colour. Although Bulwer was interested in the architectural details of churches – his many views of Norfolk churches were possibly intended to accompany an antiquarian publication, Francis Blomefield's *History of Norfolk* (first published 1753–65) – this watercolour concentrates as much on the landscape and the sky as it does on the church.

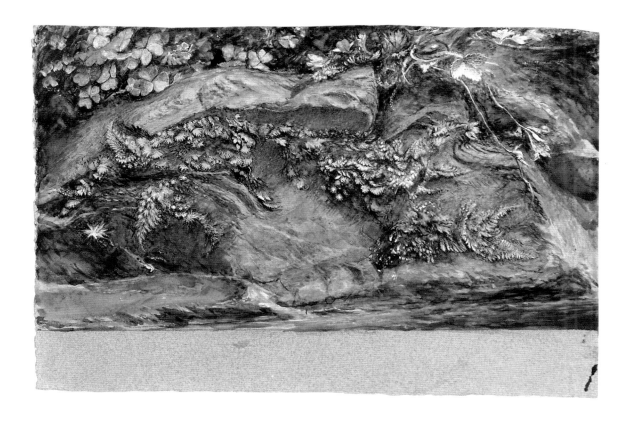

JOHN RUSKIN 1819–1900
Study of Leaves on a Rocky Riverbank 1875–9
Watercolour, pen and bodycolour on paper 17.5 × 25.7 cm
Museums Sheffield

John Ruskin is perhaps best known for his art criticism and for his close affiliation to and patronage
of the Pre-Raphaelite artists, as well as his championing of the controversial later work of Turner.
He also made many intricate studies from nature, believing that only when an artist was capable of painting
the subtle nuances of foreground detail could they paint large landscape views. Although precisely
detailed and based on observation, watercolours like this also take on a kind of visionary intensity.

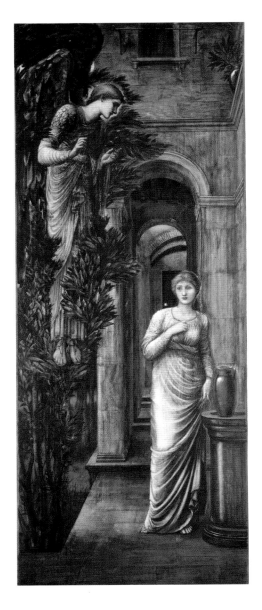

EDWARD COLEY BURNE-JONES 1833–1898
The Annunciation 1887
Watercolour heightened with gold on paper 245 × 96.2 cm
Norwich Castle Museum & Art Gallery

Edward Coley Burne-Jones was a leading figure in the later phase of the Pre-Raphaelite
movement, a group of young British artists intent on reforming British painting by looking back
to medieval and early Renaissance art. This enormous watercolour is a religious subject, showing
the moment when the angel Gabriel visited Mary to tell her that she was pregnant with the
Christ Child. The shallow space and stylised treatment of the figures in this work reflects Burne-
Jones's interest in the early Renaissance art he had studied during his travels in Italy.

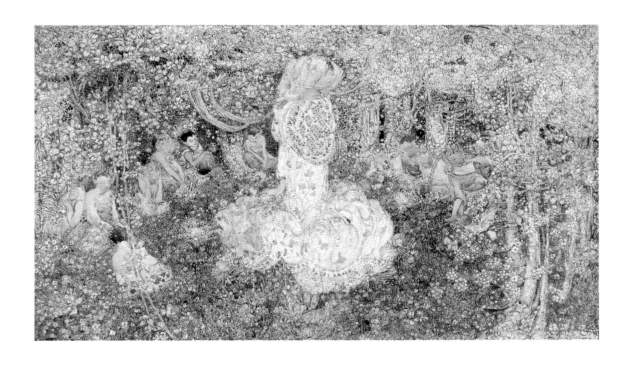

ANNIE FRENCH 1872–1965
The Lady under Enchantment 1900–20
Ink and watercolour on paper 30.5 × 50.2 cm
Laing Art Gallery, Newcastle upon Tyne (Tyne & Wear Archives & Museums)

Annie French studied at the Glasgow School of Art and was closely associated with artists of the
Glasgow School – painters and designers who wanted to combine a modern approach with Asian
and Celtic decorative influences. She was primarily an illustrator, producing book illustrations and
greeting card designs. Her works was strongly influenced by the Pre-Raphaelites and consists of
intricately drawn patterns often of naturalistic subject matter. Her work is full of fantasy and strangely
dressed figures whose clothing often blends into the elaborate patterning of the background.

ANISH KAPOOR born 1954
Untitled 1987
Gouache on paper 39 × 30 cm
Tate. Presented by the Weltkunst Foundation 1988

Anish Kapoor works as a sculptor, often on a monumental scale. His works on paper explore
notions of spirituality, the body, and the material world. Although this work is painted entirely
in gouache, it conveys a primal sense of the material. He has allowed the yellow pigment to
bleed into the brown, taking on a shape which is both complex and simple. The resulting image
is not planned but evolves through his use of the medium as an unconscious act.

SHIRAZEH HOUSHIARY born 1955
The Angel of Thought 1987
Ink wash, gouache, metallic paint, chalk and wax crayon on paper 49.8 × 69.9 cm
Tate. Presented by the Weltkunst Foundation 1987

Shirazeh Houshiary spent her formative years in Iran before fleeing in 1973 to study art in London. Her work is heavily influenced by her Persian cultural background, but takes shape through the language of western sculptural practices. This watercolour forms part of a series of works she undertook in which she sought to represent the spiritual concept of the angel and translate it into a physical reality.

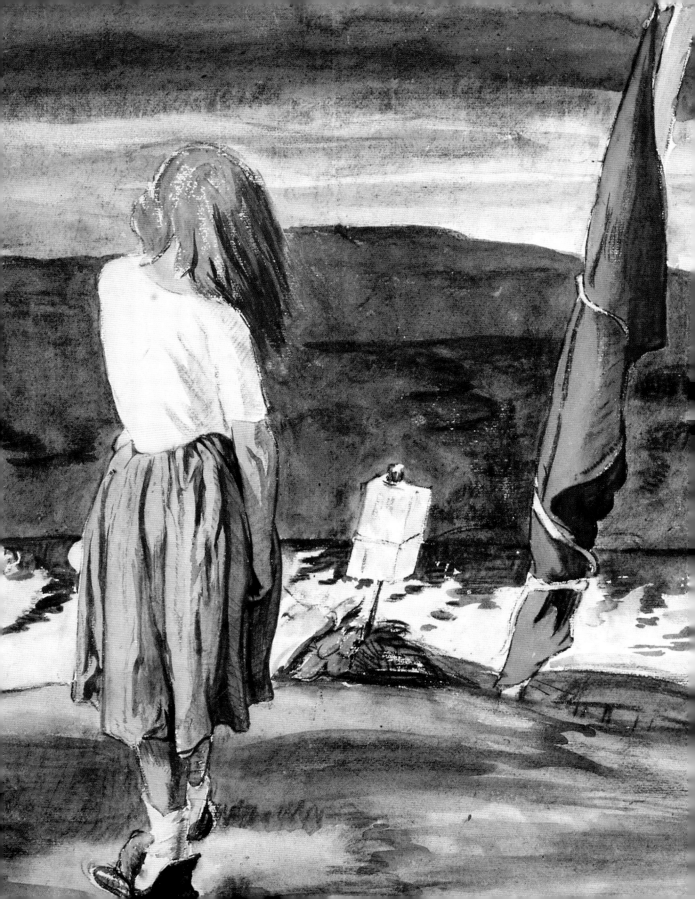

Sarah Richardson

VISION AND IMAGINATION

Watercolour's versatility and directness as a medium have proved irresistible to generations of painters seeking to realise pictorially their inspirations, emotions and dreams. The natural world, poetry, legend, spiritual belief, and the unconscious mind have all provided fruitful themes for visionary watercolourists.

The expressive response to landscape that has historically characterised British watercolours has owed much to a visionary element. According to the established art-historical narratives, during the nineteenth century watercolour views developed from topographical record-making to more imaginatively engaged compositions, infused with atmosphere, drama, and poetic feeling. At the centre of this story is J.M.W. Turner, whose pictures transformed everyday scenes into semi-abstract visions, filled with light (pp.15, 37). He often worked mostly from memory, concentrating on an emotional, imaginative response to his subjects. Turner's vision of landscape dominated one strand of British art of the 'Romantic' era. Another aspect focused on 'Sublime' features of grandeur and drama in nature, corresponding with concerns in contemporary poetry and literature. An imaginative pastoral tendency in art of the period is represented by Samuel Palmer's watercolour scenes. In *Evening*, painted in about 1880 (p.49), he exploited the emotive power of twilight over landscape, concentrating on a rural vision expressing an ideal of humanity at one with nature. Like Palmer, the nineteenth-century art critic and artist John Ruskin found evidence of divine creation in landscape, but took a closer focus, recording minute details of nature with the hyper-real intensity of a dream (p.39).

Many artists with a revelatory message, such as William Blake, were drawn to the clarity and freshness possible with watercolours. Working in the late-eighteenth to early nineteenth centuries, Blake variously employed transparent, radiant colour or deep, glowing hues, complementing the nature of his visionary and contemplative subject matter (pp.36, 48). His inner visions seemed to him images of a reality hidden from normal sight, which the flat washes of his pictures allowed him to communicate without interference

EDNA CLARKE HALL, *Catherine* c.1924 (detail, see p.56)

from the physicality of thick paint and brushwork. In contrast, Edward Burne-Jones endeavoured to convey the impact of angelic revelation in dense, rich watercolour combined with gold leaf in his picture of *The Annunciation* of 1887 (p.40). Although influenced by Pre-Raphaelite art, by this date he had developed a freer technique than his mentors, and this picture is on a huge scale. The twentieth-century artist David Jones admired the 'overwhelming' power of Blake's visionary watercolours, and his own compositions originated in a comparable intensity of religious and lyrical feeling. In *The Mother of the West* (p.55), he created an ethereal web of images and allusions; the Christian Lamb of God is suckled by the Roman wolf of legend while surrounded by imagery of war together with Classical and Christian symbols.

The imaginative worlds of poetry and literature attracted visionary artists over the centuries. The idealised worlds of Arthurian legend and heroic times past were favourite themes of Pre-Raphaelite painters such as Dante Gabriel Rossetti and Elizabeth Siddal, who fashioned their romantic visions with jewel-like colours and meticulous detail (pp.17, 50). For these pictures, they used a consciously archaising style that Pre-Raphaelite artists considered 'truthful' to their subject matter. Their poetic, imaginative scenes often have a claustrophobic, sensual quality, and this is also a feature of *Jealousy* (p.51), a picture with a generalised chivalric ambience, painted by Rossetti's friend, Frederick Sandys. The pierced heart in the background represents the pain of jealous love sparked by the androgynously handsome young man featured in the scene (the kind of youth that nineteenth-century critics referred to as 'hyper-poetic'). Themes of Arthurian legend also attracted Jones, while Annie French, one of the artists in the orbit of Charles Rennie Mackintosh in the early twentieth century, painted a fairy world drawn from poetry and stories. Her picture of *The Lady under Enchantment* (p.41) probably illustrates a Scottish legend of a beautiful Green Lady, once mortal but placed under enchantment; the intricate patterning of the picture helps to establish a hypnotic atmosphere of magic. Working around the same time, Edna Clarke Hall found inspiration in the romantic nineteenth-century story of Emily Brontë's *Wuthering Heights*. Isolated by a difficult marriage, Clarke Hall often used her interpretations of the book to express her feelings at times of personal crisis; in *Catherine*, painted in about 1924 (p.56), the girl's pose and the bleak landscape seem to express both alienation and introspection.

Dreams and the power of unconscious impulses were primary themes for twentieth-century artists allied to the Surrealist movement. The spontaneity of watercolours, whether in the form of transparent washes or thick gouache, allowed artists to re-visualise their dreams, obsessions and fears in a very direct manner. The artists include such disparate figures as Robin Ironside, who

considered himself to be working in an imaginative tradition derived from William Blake, and Conroy Maddox, who dedicated himself to the original anarchic principles of the International Surrealist movement. While Edward Burra was always an individualist, many of his watercolours have a surreal quality. *Soldiers at Rye* (p.52) was painted during the Second World War, and conveys a sense of threat with a homosexual undercurrent, expressed by the soldiers' bulging muscles and buttocks together with their bizarre beaked masks.

The turmoil of the Second World War prompted an imaginative response in many artists. They include John Piper and Graham Sutherland, whose approach was described as 'Neo-Romantic', reflecting the drama of the wartime world in heavy black shadows with powerful colours. In Sutherland's picture of a destroyed factory, a surreal, baleful quality emanates from the composition of huge, semi-burned rolls of paper set against a strange mustard-coloured background (p.54). Sutherland also found surreal elements in landscape, exaggerating and animating small details so that they took on a new, sometimes threatening, character.

Sutherland prized watercolour for its glowing colours, but also cherished the ability of gouache to create an impact comparable to oils. His work reflects how the specialism of watercolour painting as a separate category broke down from the 1930s onwards, with many artists using a variety of media. Nevertheless, watercolour continues to have much to offer artists working with visionary subject matter. Modern visionary watercolourists include Christopher Le Brun (p.57), whose enigmatic, imaginative compositions draw on mythology, poetry, and art of the past.

Over the centuries, the imaginative tradition has provided a powerful creative drive for watercolour painters. Visionary inspiration, in its many forms, has enabled artists to connect with deep-set emotions and impulses within the human psyche, resulting in art that is often moving, intriguing, and uplifting.

WILLIAM BLAKE 1757–1827
Epitome of James Hervey's 'Meditations among the Tombs' c.1820–5
Pen and ink and watercolour on paper 43.1 × 29.2 cm
Tate. Presented by George Thomas Saul 1878

This intricate image has been interpreted as a summation of William Blake's understanding of the
Bible, drawing upon James Hervey's *Meditations* (1746). Hervey was a Calvinist minister and a popular
religious writer, and Blake based this watercolour upon Hervey's reflections on death, mortality and
the Resurrection. But he was also making a personal statement about his own, more idiosyncratic,
religious views: Hervey himself is pictured in the watercolour before an altar. The painting also
suggests Blake's interest in medieval art. The centre of the composition is taken up by a large Gothic
stained-glass window encompassing a winding staircase with scenes from the Old Testament.

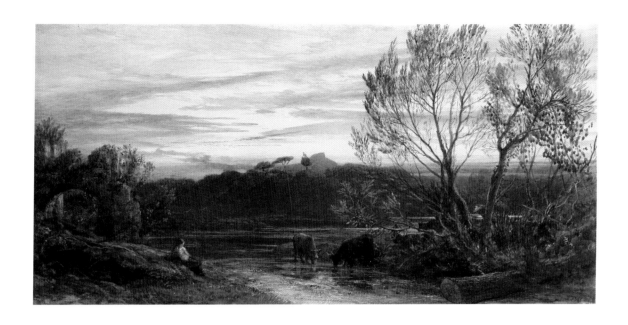

SAMUEL PALMER 1805–1881
Evening c.1880
Pencil and watercolour on paper 27.3 × 52.7 cm
Norwich Castle Museum & Art Gallery

In this painting a single figure in the left foreground sits within a wide pastoral scene, immersed in melancholy thoughts whilst observing the wonders of the natural world and the passing of another day. Samuel Palmer was particularly famous for his dramatic skies in which he expertly caught the varying light effects of the different times of day. Although he was a friend and huge admirer of William Blake, and produced landscapes directly inspired by the example of that artist earlier in his career, his later works, like this, took a more conventional form.

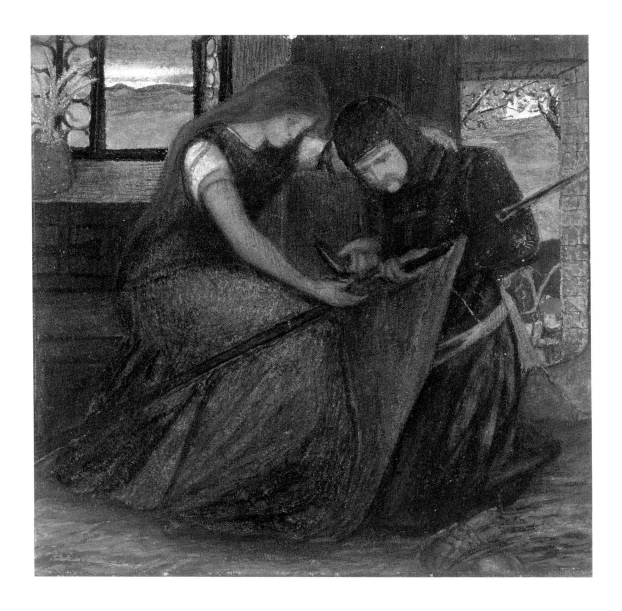

ELIZABETH ELEANOR SIDDAL 1829–1862
Lady Affixing Pennant to a Knight's Spear c.1856
Watercolour on paper 13.7 × 13.7 cm
Tate. Bequeathed by W.C. Alexander 1917

Elizabeth Eleanor Siddal became an artist almost by chance. Whilst working in a millinery shop in Leicester
Square she was noticed by the artist Walter Deverell, who asked her to model for him and his group of friends
who later became the Pre-Raphaelite Brotherhood. She eventually only sat for Dante Gabriel Rossetti, who
saw her skill for drawing and proceeded to give her lessons As with the Pre-Raphaelites, her work concentrated
on themes of medieval literature and many of her works were illustrations to poems by Tennyson.

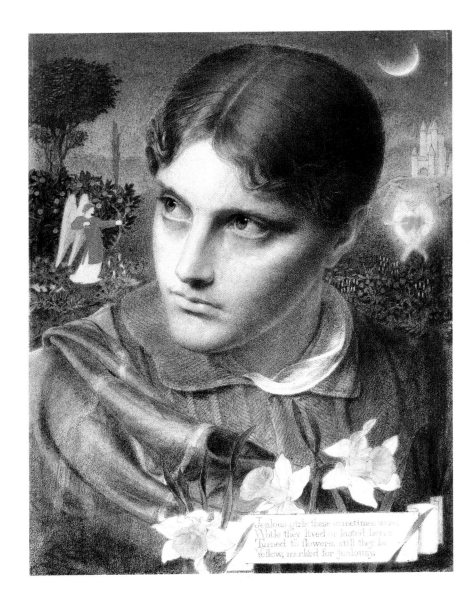

ANTHONY FREDERICK AUGUSTUS SANDYS 1829–1904
Jealousy 1860s
Watercolour on paper 36.1 × 26.6 cm
Laing Art Gallery, Newcastle upon Tyne (Tyne & Wear Archives & Museums)

Anthony Frederick Augustus Sandys began his artistic career at an early age painting birds and topographical watercolours of Norfolk. He later became a member of the Pre-Raphaelite circle and took much inspiration from Dante Gabriel Rossetti (p.17). This watercolour depicts a figure of a young man set before an allegorical background; the pierced heart possibly refers to the pain of unrequited love. The short poem was written by Robert Herrick and called 'Why Marigolds Turn Yellow'. Herrick was a seventeenth-century songwriter who became popular in the nineteenth century.

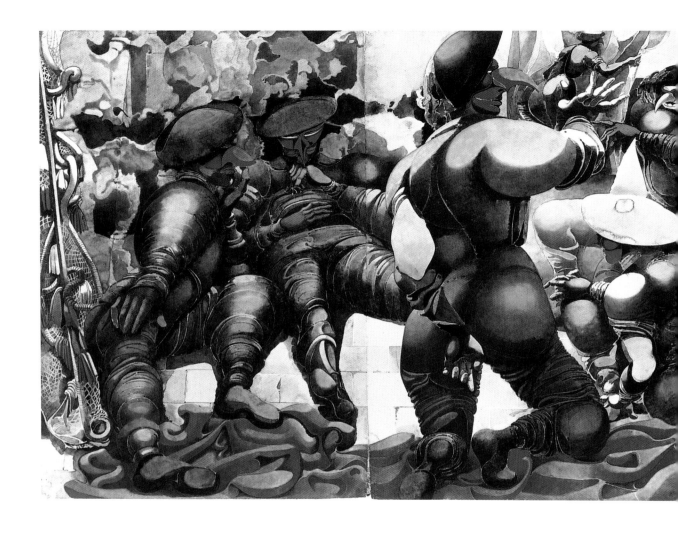

EDWARD BURRA 1905–1976
Soldiers at Rye 1941
Gouache, watercolour and ink wash on paper 102.2 × 207 cm
Tate. Presented by Studio 1942

Edward Burra used watercolour on an unusually large scale, on heavy watercolour paper, so that his pictures take on the visual qualities usually associated with oil painting. Although the themes of his art reflected his travels and experiences around Britain and the wider world, during a time of war and conflict, he did not simply use the medium to record his observations; pictures like this explore dream-like images, and convey a sense of danger and strangeness. This picture presents a scene of military activity near Rye, where he lived, in highly imaginative, and even somewhat sexualised, terms.

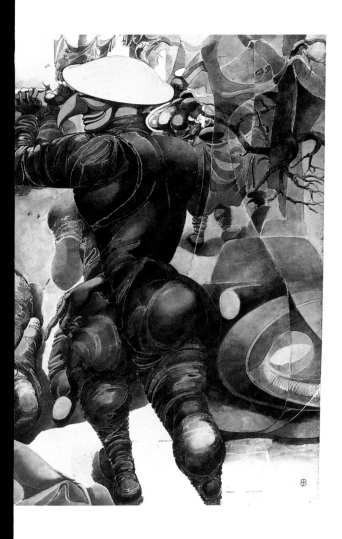

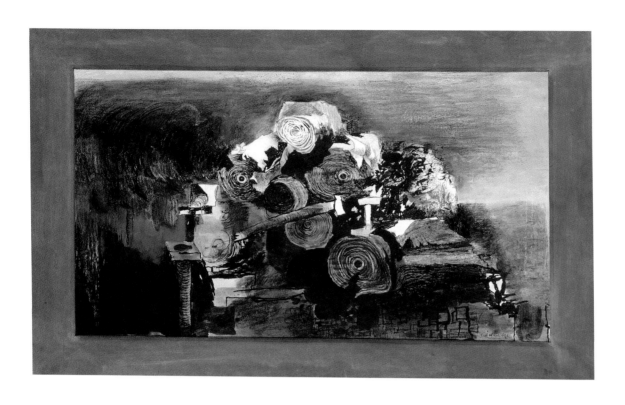

GRAHAM SUTHERLAND 1903–1980
Devastation, 1941: East End, Burnt Paper Warehouse 1941
Gouache, pastel, pencil and pen and ink on paper mounted on card 67.3 × 113.7 cm
Tate. Presented by the War Artists Advisory Committee 1946

Graham Sutherland was officially employed as an artist during the Second World War, recording
his observations of the impact of war around the country. Although nearly abstract, the spiral forms
at the centre of the composition are based on the great rolls of paper that Sutherland saw in the
wreckage of a bombed warehouse in London. Sutherland recalled: 'During the bombardment
of London, on a typical day, I would arrive there from Kent ... with very spare paraphernalia ...
and an apparently watertight pass which would take me anywhere within the forbidden area.'

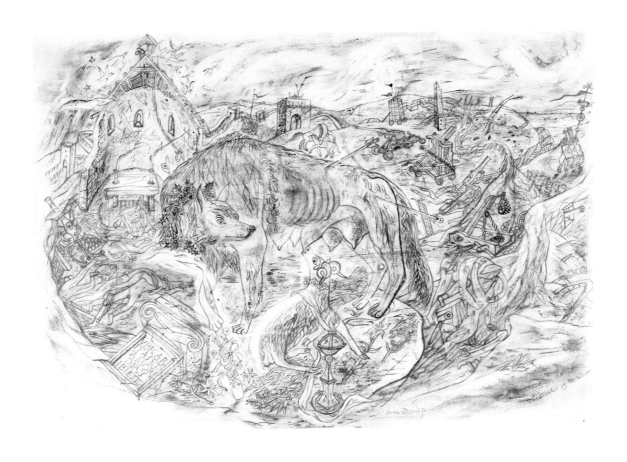

DAVID JONES 1895–1974
The Mother of the West c.1942
Ink, pencil and watercolour on paper 25.6 × 35 cm
Laing Art Gallery, Newcastle upon Tyne (Tyne & Wear Archives & Museums)

Much of David Jones's poetry and art was informed by his Welsh heritage, his Catholicism and
his experiences of war. This densely drawn work illustrates elements of the story of Romulus and
Remus, the legendary founders of Rome. Rather than depict the two young children suckling from
a wolf as original story states, Jones replaces them with the image of a symbolic Lamb of God. The
lamb refers to the emergence of Christianity from the wreck of the Roman Empire. He adds a
contemporary element to the scene by strewing the landscape with modern items of warfare.

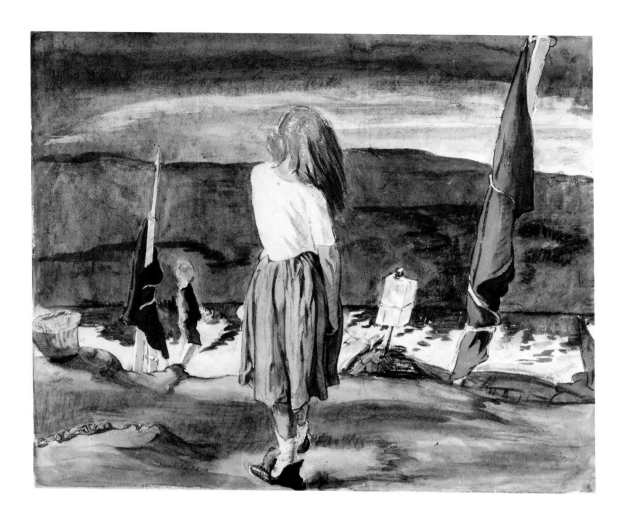

EDNA CLARKE HALL 1879–1979
Catherine c.1924
Pencil and watercolour on paper 47.7 × 57.8 cm
Laing Art Gallery, Newcastle upon Tyne (Tyne & Wear Archives & Museums)

Edna Clarke Hall trained as an artist at the Slade in London, but after marriage was discouraged from pursuing art by her husband. The watercolours and drawings she did produce often focused intensively on her favourite novel, Emily Brontë's *Wuthering Heights* (1847), and the novel's tragic heroine, Catherine. The desolate nature of the novel, and of the landscape of the Yorkshire Moors where the book is set, seemed to resonate with Clarke Hall. The solitary figure of Catherine, seen here set against the bleak moorland landscape can be interpreted as a poignant symbol of the isolation and struggle of many women artists.

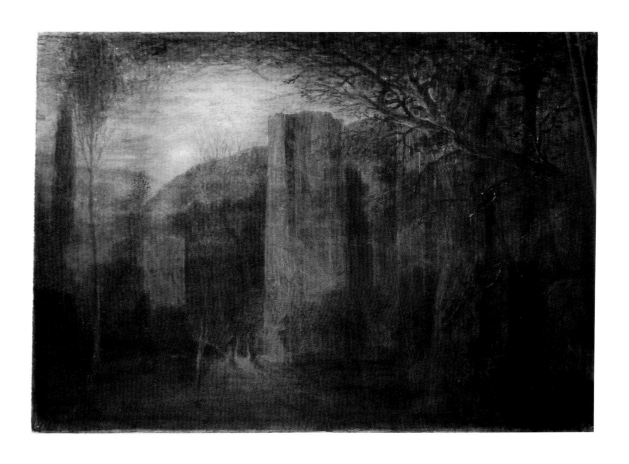

CHRISTOPHER LE BRUN b.1951
Towers with Moonrise 2006
Watercolour on paper 56 × 77 cm
Courtesy of the artist

Christopher Le Brun emerged as an artist in the 1980s, creating large-scale oil paintings that both looked back
to the mythological and dream-like imagery of painters such as Arnold Böcklin and Gustave Moreau, and
evoked the painterly abstraction of post-war American art. In the last few years he has also turned to
watercolour for the first time. His watercolours present dreamy, romantic landscapes, clearly evocative of the
imagery of Turner and his contemporaries, though often punctuated by strange, brightly coloured structures.

SELECTED BIBLIOGRAPHY

Alley, Ronald. *Graham Sutherland*, exh. cat.,
Tate Gallery, London 1982

Bonehill, John and Stephen Daniels (eds.).
Paul Sandby: Picturing Britain, exh. cat.,
Royal Academy of Arts, London 2009

Brown, David Blaney. *Turner Watercolours*,
London 2007

Cohen, Marjorie B. *Wash and Gouache:
A Study of the Development of Materials of
Watercolor*, Fogg Art Museum, Cambridge,
Mass. 1977

'Constructive, Investigative and Truthful:
Christopher Le Brun Interviewed by Cecilia
Powell on J.M.W. Turner and Watercolour',
Turner Society News, August 2006 and online

Gowing, Lawrence. *Turner: Imagination and Reality*,
exh. cat., The Museum of Modern Art,
New York 1966

Hoozee, Robert (ed.). *British Vision: Observation
and Imagination in British Art, 1750–1950*, exh. cat.,
Museum voor Schone Kunsten, Ghent 2007

Finberg, A.J. *The English Water Colour Painters*,
London 1905

Hardie, Martin. *Water-colour Painting in Britain*,
3 vols., London 1966–8

Hills, Paul. *David Jones*, exh. cat.,
Tate Gallery 1981

Lewison, Jeremy. *Anish Kapoor: Drawings*,
exh. cat. Tate Gallery 1990

Lister, Raymond. *Catalogue Raisonné of the
Works of Samuel Palmer*, Cambridge 1988

Mellor, David. *A Paradise Lost: The Neo-Romantic
Imagination in Britain 1935–55*, exh. cat., Barbican
Art Gallery, London 1987

Myrone, Martin. *The Blake Book*, London 2007

Reynolds, Graham. *Watercolours: A Concise
History*, London 1998

Richardson, Sarah. *British Watercolours:
Exploring Historic and Modern Pictures from the
Laing Art Gallery*, Tyne and Wear Museums,
Newcastle 1993

Sloan, Kim. 'A Noble Art': Amateur Artists and
Drawing Masters c.1600–1800*, exh. cat.,
The British Museum, London 2000

Smith, Greg (ed.). *Thomas Girtin: The Art
of Watercolour*, exh. cat., Tate Britain,
London 2002

Smith, Greg. *The Emergence of the Professional
Watercolourist: Contentions and Alliances in the
Artistic Domain, 1760–1824*, Aldershot 2002

Spalding, Julian. *The Art of Watercolour*, exh.
cat., Manchester City Art Gallery 1987

*A Splash of Colour: 20th Century Watercolours from
the Laing Art Gallery*, Tyne and Wear Museums,
Newcastle 1998

Treuherz, Julian, Elizabeth Prettejohn, Edwin
Becker. *Dante Gabriel Rossetti*, London 2003

Wildman, Stephen, et al. *Edward Burne-Jones:
Victorian Artist-dreamer*, exh. cat., Metropolitan
Museum of Art, New York 1998)

Wilton, Andrew, and Anne Lyles. *The Great Age
of British Watercolours 1750–1880*, exh. cat., Royal
Academy of Arts, London 1993

JOHN ROBERT COZENS, *Lake Albano and Castel Gandolfo* c.1783–8 (detail, see p.24)

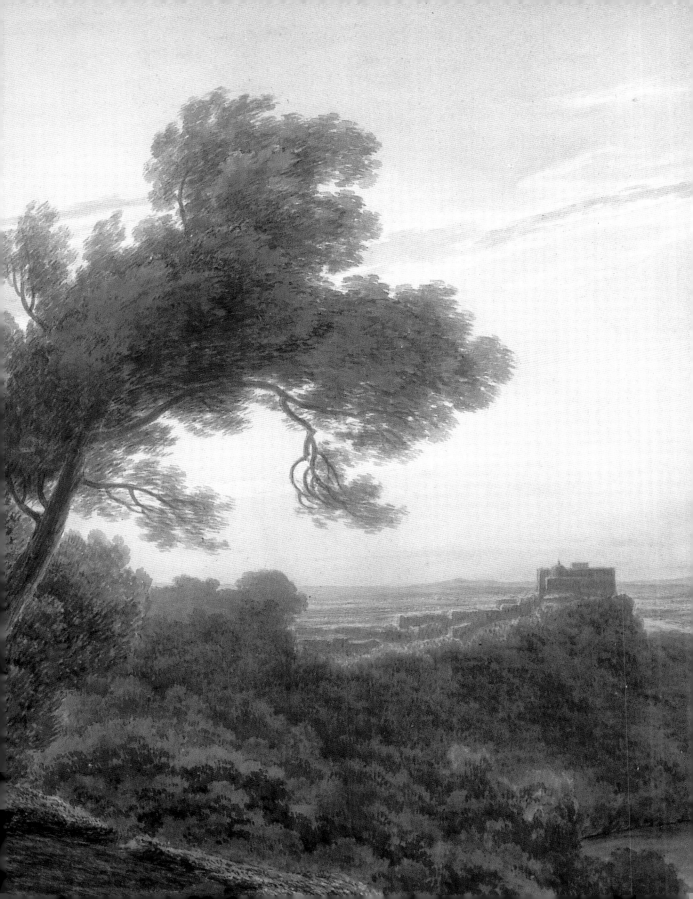

CREDITS